ART-WRITE:

THE WRITING GUIDE FOR VISUAL ARTISTS

Crafting Effective Artist Statements and
Promotional Materials

by Vicki Krohn Amorose

LUMINARE PRESS
EUGENE, OREGON

Art-Write: The Writing Guide for Visual Artists
© 2013 Vicki Krohn Amorose

Printed in the United States of America

Dorothea Lange photos, pages 54-56, courtesy of Library of Congress, Prints and Photographs Division

Cover Design: Paul Mavrides

Luminare Press
467 W 17th Ave
Eugene, OR 97401
www.luminarepress.com

LCCN: 2013930288
ISBN: 978-1-937303-12-9

This book is dedicated to my dear husband,
David Amorose

Contents

Preface:
Words Are Powerful

LANGUAGE AND IMAGE CONNECT IN MYSTERIOUS WAYS.
I first experienced this connection as an art history student. In darkened lecture halls, gazing at detailed slides of art I'd never seen before and listening to a flow of descriptive words, I entered a state of true amazement. To the credit of my professors, at the end of each class I not only knew so much more, but I could see so much more. Somehow, words combined with images had changed my brain. These art history lectures actually increased my ability to see.

I was very fortunate to have Rudolph Arnheim as a professor. His classic text books, *Art and Visual Perception* and *Visual Thinking,* are dense with theory, but I can tell you, in person, the man himself always seemed joyous—as if nothing could be better than speaking to this group of students about this subject at this moment in time.

Before you delve into *Art-Write*, I'd like to simplify and share some of what I learned from Dr. Arnheim. His insights illuminate the path to writing about your art.

The Arnheim Insights

- The act of "seeing" or "looking" is not a simple process
- Seeing takes time to accomplish
- Just as an artist toils with his or her own powers of perception and sense of vision to create a work of art, the viewer toils with his or her own powers of perception and sense of vision to "see" a work of art
- Language shapes perception

When you consider these useful ideas, you can begin to understand how your audience approaches your artwork. Truly "seeing" art is an accomplishment. It doesn't happen quickly. Your viewers need time and they may need some education. Language can help educate them.

You, the artist, talking and writing about your work, are in a position to provide language that shapes perception. Words are powerful, and you can use them to help your audience see.

Introduction:
Why Visual Artists Need to Write

THIS BOOK HAS A SINGLE INTENTION: TO TEACH YOU HOW to write about your art.

When you imagined a life in the visual arts, maybe you didn't consider writing as an important part of the picture. Our current communication and media environment consistently asks artists to write about their work. Today, the worlds of the plugged-in entrepreneur and the working artist have converged, with self-promotion essentially linked to writing. Your own clear writing on the subject of your art is the key to marketing yourself, which can also be the key to making a living as an artist. It's that important.

Art-Write will prepare you to communicate who you are as an artist.

It's tempting to dismiss the need for writing and claim, "There is no reason to explain my art. Everything I have to say is in the work itself." That's a tired and dated re-

frain. If you want people to find your work, to understand and follow your career, to talk about you, write about you and—yes indeed—buy your art, you need to embrace self-promotion.

And the self-promotion engine is fired on the power of words.

There is a rarified sub-set of wealthy artists who don't need to write about themselves. They can rely on professional art writers who are able to transform their perceptions into concrete language.

But you, along with the vast majority of artists, will need to take on the task of learning how to do this for yourself.

The writing you do about your work is often used directly—word for word—for these purposes:

- Press releases for art shows and events
- Invitations to art shows and events
- Gallery publications, both online and print
- Descriptions displayed on the walls of art booths, galleries, and museums, or placed in the gallery's "artist book"
- Training for gallery staff and museum guides
- Media quotes, both online and print
- Cover letters
- Your personal website
- Artist group websites
- Content for your blog
- Quotes for other people's blogs

- Social media communication
- Submissions to juried shows
- Submissions for art/craft fair booths
- Applications to art schools
- Grants

Forms and proposals for:

- Artist-residency programs
- Foundation awards
- Teaching opportunities
- Scholarships
- Public art commissions

You'll also find you need to write for a wide variety of reasons, including:

- *Writing for the different stages of your career:* Good writing can aid you no matter where you are in your career. When applying to school, writing can help distinguish your application from hundreds of others. While building a career, you'll need to communicate with galleries or apply for grants. Sustaining an income often means finding new connections and new streams of revenue, putting yourself out there again and again. As your work develops, you'll need to describe those developments to collectors. When you've achieved recognition and acclaim, art writers and art appreciators clamor to know what you think. And writing is indispensible for the success of your reinvention, a familiar stage to most creative types.

Writing to connect: In order to launch, improve, or maintain art sales, you will need to reach gallery owners, show jurors, news writers, art writers, bloggers, collectors, dealers, and funders. If you can clearly express yourself, *in words*, you can get their attention. No one can predict how the Internet, the economy, and other factors will impact the art world in the future, but one thing is fairly certain: if you are *not* willing or able to communicate in written language, you will greatly reduce the chances of getting your artwork noticed. People form impressions of you based on how you write. This is true whether you're writing an e-mail, a cover letter, or posting to social media.

• *Writing to impress the press:* What you write about yourself affects what is written about you. Media-relations professionals rely directly on the writing you do! The Internet has altered traditional publishing in ways that continue to unfold. Few news outlets have dedicated art critics and art writers—they never had many to begin with, and the pool is dwindling. The news writers who are left will use any information you can provide. Make their job easier; help them understand your work by describing it well. Give them clear, considered sentences and they might return the favor by putting your name in print.

• *Writing as a prepared business person:* You've probably been asked at some point to produce an artist statement or something similar. Did you grab at scraps of advice, frustrate yourself searching for good examples, and then patch

together words for a deadline? Avoiding your written communication until it becomes a despised last-minute chore makes no business sense, and you are in the business of art. You don't need to write lengthy essays or manifestos. Just a small amount of well-crafted text will serve you well. You *can* learn to sort out your thoughts so you'll be able to write and speak about your art with clarity. You can learn how to keep a file of art writing that helps calm your writing anxiety and boosts your confidence when you need to present yourself professionally.

• *Writing to call attention to your art on exhibit:* When you're asked to write about your art, it's important to act on the opportunity. For example, let's say you're accepted in a group show on the merit of images alone. The show organizers want to gather information about artists and they request commentary from you. But it was only a request, so you do not provide any writing. To generate publicity, the show organizers will send out a press release and describe the show online. This leaves the writing you didn't do in the hands of the show's default writer/editor, who is most likely doing several other jobs. If another artist has provided a print-ready statement about their work, guess which one of you will get more attention and whose art will be featured in the publicity material? When you provide an artist statement, written in a way that effectively connects with a reader, it will serve to enhance your visual statement wherever you exhibit your work.

Art advocates of all kinds will appreciate the assistance of you providing them with articulate text to accompany your work. It is an art *world,* after all. We are connected and we can help each other.

How this book can help

You ask yourself, "How do I begin to put this into words? How do I describe this process I go through? What am I supposed to say, anyway? *What do you people want from me?*" You read about how to include an artist statement in a grant, and it's like following assembly instructions whose first step is, "Insert the screw into slot A." You don't have a screw. So you're screwed.

I understand your frustration, and I've written *Art-Write* to provide you with solid, practical tools that will break down the job, step-by-step, starting at the beginning. Writing about art is not easy, and writing about your own work is even harder. But you didn't choose the path of an artist because it would be easy. If "Artist" were a job description, you probably wouldn't apply—considering the salary, benefits, bonuses, working conditions, and retirement plan. You are an artist because that's what you are. You already have the job. Following the guidelines in *Art-Write* just might help you keep it.

Let's end the cycle of copying weak examples and start writing artist statements that work!

Writing is part of an artist's job description in the 21st century, and *Art-Write* will provide some on-the-job training. An artist statement is typically brief, only one paragraph to one page in length. And yet, good examples are hard to come by.

Art-Write will provide the "how-to" for this very particular writing task, even if you consider yourself a non-writer. Throughout the book, I'll give you definitions, prompts, and advice. We will begin by crafting your artist statement, which is the foundation of writing about your artwork. I'll help you clarify your thoughts about your process, and then teach you how to turn those ideas into useful prose.

> You don't have to translate into words the entire content of what you've already expressed visually! Your task is to give your audience a compelling reason to look closer. Help them look.

I'll provide exercises that will lead you to find words that feel correct and authentic. I'll offer advice to help you break through the barriers you may have about expressing yourself in writing. And finally, I'll show you how to re-cycle the thoughtful sentences you've developed and apply them to a range of career opportunities.

Only *you* think what you think and make what you make, so you are the most informed person to write about

the work you've produced. However, some of you may wind up hiring a professional writer to help you. These writers won't be magicians; you'll still have to provide them with the necessary core. Completing the exercises and prompts in this book will give you something to hand over to a hired writer, because the content and the truth come from inside *your* head.

Writing about your work is an interesting part of the artistic process. It's worth the effort. You'll create a valuable record of your development. Writing brings personal insight, it helps you gain perspective and understand yourself better. It also provides a framework for you to *speak* about your ideas in ways that can be understood. Describing what you do is essential to confident and clear communication, which will make your work accessible to a wider audience. We all want more people to discover more art.

I don't want to market myself!

Are you approaching the necessity of self-promotion with resentment, wishing for an agent or a gallery to take care of all of this annoying marketing/selling/writing stuff?

Some artists think self-promotion is intrinsically icky. They can grasp the benefits of self-promotion, but they just don't want to get involved. You may have to set aside resistance, avoidance, and anxiety in order to make this task manageable.

I suggest you embrace the following concepts, which are shared by both art and self-promotion:

- communication
- expression
- message
- connection

I collect seashells. While I wrote this book, my husband gave me the shell of a rare paper nautilus. Extremely fragile and weighing next to nothing, it is the egg case from a type of octopus. The female creates the paper nautilus inside her body and pushes it out. After she deposits her eggs inside, she crawls in the paper nautilus and takes shelter there also. The more common chambered nautilus is a creature that propels itself forward, shell first, without the help of forward-facing eyes. So it sometimes smashes its shell on rocks or coral. With the protective shell broken, it dies.

Artists have shells, and some of those shells are more fragile than others. Artists protect the thing that is most precious: our creative inner lives and our ability to make art. We have to protect it because no one else will. Society, school, family, and even close friends can act in a way that devalues the very thing we value most. We become accustomed to defending, guarding, and sometimes hiding our art life. Writing about our work and selling ourselves feels like the nautilus propelling itself forward, shell first, with no idea if the future holds open water or a damaging collision.

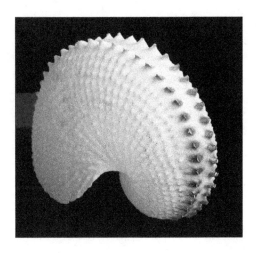

The artist who is also a marketing genius is a rare combination. Artists with quiet profiles—those who lack the media savvy of Andy Warhol, Jeff Koons, or Damien Hirst—are in the majority. Most artists wish for someone else to come along and sell their work. This may happen. In the meantime—and I do mean "mean"—the rent is due, the day job eats up all your time, and the needed studio space is unattainable. The shell might break, not because you propelled forward, but because you're going nowhere and you sink.

If you can begin by completing a few paragraphs—describing what you do and why you do it—you are on your way. The paper nautilus has an air chamber so it can float near the surface. That's really all an artist's self-promotion needs to be: floating near the surface. Keep the shell if you want. Write something for the buy and sell culture and go back to your real work.

PART ONE

DEVELOP YOUR ARTIST STATEMENT

Definition of Artist Statement

Your artist statement will be the first thing you write, and it becomes the foundation for longer or more targeted writing. I will ask you to keep your notes throughout the entire process of crafting your statement. Hold on to the phrases and sentences you edit out of your final statement; they could prove useful for other forms of promotional writing.

What an artist statement IS NOT

An artist statement is not art. It is not a full translation of a visual statement into a verbal statement. The writing does not need to encapsulate all of your creative striving and complexities. It does not need to be entirely original or brilliant, and say everything you want to say to the world.

What an artist statement IS

An artist statement is a concise arrangement of words that acts as a bridge to connect your audience to your art.

This definition is important because it helps to clear up the confusion about the many forms an artist statement can take. Statements may describe an entire body of work, a series, or a single art piece. Others are written to impress a jury, win a grant, or land a commission. Art teachers may require a student to write in the context of art theory. Some artists use their statements as expressions of personal belief. Some intend them purely as a sales tool. All these types fit within this definition. Although the form may vary depending on the context, the basic definition remains the same.

An artist statement is a concise arrangement of words that acts as a bridge to connect your audience to your art.

Connect with Your Audience

IF YOU REMEMBER ONLY ONE THING FROM THIS ENTIRE book, remember to **keep your audience in mind while you're writing**.

This is more important than you may realize.

Who is your audience?

> Your audience is anyone who might buy your art, especially if they understood more about it.
>
> "To **buy**" means "to purchase."
>
> "To **buy**" also means "to accept, believe, or to take seriously."

Pay attention to the definition of *audience* in this context; the definition is limited for good reason.

If you like to write, and the audience I describe feels too confining, then find other outlets for your writing. If you want to discuss art theory and politics, communicate with

like-minded thinkers, or shred your enemies, go to online forums. Write your rants and manifestos in a blog or journal. Find a place to write in unrestrained prose.

Want a brilliant example? Artist Ai Weiwei's blog is now published as a book, *Ai Weiwei's Blog: Writings, Interviews and Digital Rants*, by Ai Weiwei and Lee Ambrozy.

The more you write, the easier the words will come when it's time to describe your work. But when you're writing your artist statement, you'll need to reign in your self-expression.

To present yourself professionally, concisely, and effectively, address the people who might "buy" your work. It's easy to get off track if you write without holding on to this definition. All writing that represents you in the light of self-promotion needs to be directed at a defined and well-considered audience. Whoever reads your statement is attempting to understand your artwork. Respect their attempt to learn about you, and you'll improve your chances of connecting with them.

Remember this key phrase in the definition of an artist statement:

*An artist statement is a concise arrangement of words that acts as a bridge to **connect your audience** to your art.*

Let's examine who your audience is NOT. You are not writing to answer critics, impress your ex-professor or former girlfriend, or amuse yourself and your friends.

Here are a few more ways to misfire:

You are NOT talking to your therapist

Somewhere along the way, you may have picked up the notion that writing about your art means communicating all that's going on inside your head. You don't have to do that! In fact, please don't! Say one thing clearly. Then say another thing clearly. When it starts sounding muddled or self-obsessive, stop writing.

The act of writing about your work will often help you understand your process, clarify ideas, and reveal new insights. But writing your artist statement is not about voicing your every thought. Your inner monologue is a confusing mess of contradictions, a struggle between self-doubt and inflated ego. Of course it may include all kinds of things that you think are fascinating, but probably only your therapist or maybe a patient loved one will agree; anyone other than that will find your inner monologue tiresome. As the child psychiatrist said to his chatty daughter, "Honey, some of your ideas can just be *thoughts*."

Your task is to communicate your insights and ideas to an audience in a way that *they* might find interesting.

You are NOT writing to argue with a person, group, or ideology

If your art is political, or emotionally charged, explain why the issue moves you instead of why the issue should move the audience. Avoid telling other people how they should feel.

> You must respect your audience enough to let them feel what they feel and think what they think in the presence of your work.

There is a difference between being angry and being argumentative. Your audience is reading your statement to learn what you're about, not to engage in some assumed intellectual conflict. An argumentative tone in your writing will just turn the audience away. Let your art confront and argue your point; let your writing present your message in plain language, or merely introduce the topic of your work.

You are NOT writing to impress other artists or art experts

Reduce the artspeak in your statement to a minimum. By "artspeak," I'm referring to the vernacular of visual artists. These specialist terms, so familiar to you, can make non-artists feel uninformed and unconnected. Artspeak tends to describe art in general, yet fails to communicate what is singular and distinctive about *your* art.

Of course you'll use art vocabulary to describe your work. You'll have to judge for yourself if your chosen art terms genuinely help to get your point across, or if you're just stretching out sentences with echoed phrases. You run the risk of distancing your reader and dulling your individuality when you overuse artspeak.

The exception: If you're reading this book while in art

school, you have a specialized audience of artists and academics. You probably use lots of artspeak, which is appropriate for your environment. You're currently surrounded, as you may never be again, by people who communicate using art terminology. Ask your teachers what they think about the following list of bulleted questions.

Examine your writing and ask yourself:

- Do these words truly help to explain what people are seeing?
- Is there a sentence I could translate from artspeak into plain language?
- Is this the truth?
- Do I fully understand what I just wrote?
- What words might create a better understanding for the reader?

Simple consideration for your reader goes a long way toward adopting a tone of directness and truth. Your readers/viewers will perceive your attempt to connect with them through the written word.

Connecting your audience to your art is important—very important. Because, in the end, they might just **buy it.**

*Your audience is anyone who might **buy** your art, especially if they understood more about it.*

"To buy" means "to purchase."

"To buy" also means "to accept, believe, or to take seriously."

Tone and Truth

ONCE, MANY YEARS AGO, MY SISTER KATE AND HER friend Gerard attended an opening at the San Francisco Museum of Modern Art. Upon arriving, Gerard stuffed himself full of free food from the appetizer table. Afterward he and Kate strolled through the main gallery. Gerard, gassy from the buffet, loudly let loose with fart after fart. He told Kate, "Just keep walking, no one will notice."

Kate was both mortified and amused. After a time, a well-dressed older gentleman approached them. Slowly enunciating in a slight British accent, he said, "This is an aaht museum, not a faaht museum."

There's a tone in art writing I like to call "the fart museum." You know it. It's that cloying odor of someone taking themselves far too seriously. The author dredges up art terms from some mildewed vault of expertise and pre-

tension and spreads words around to obscure any authentic feeling.

Beware. The fart museum tone is highly contagious! I find my own writing slipping into it after reading too many art books and reviews. The main clue that you are writing from inside the fart museum is when you seem to have lost your enthusiasm for your subject. This is YOUR art you're writing about! If you aren't enthusiastic about it, how do you expect anyone else to be? Pay attention when you sit back and think, "I'm boring *myself* right now!"

Sometimes you get stuck in your writing because you're not being truthful. You may be saying things you think people want you to say or mimicking a tone that sounds erudite. The problem is intensified when you read forceful quotes from famous artists or beautifully framed dogma from art-world elites. Find your own voice. Tell the truth about your work. The truth is interesting; the fart museum stinks.

Three Rules You Won't Follow

ARTISTS HATE RULES, AND WE LOVE TO IGNORE THEM. Truth is, good writers challenge the rules all the time. Although there are useful rules of the English language and you'll be a better writer if you know them, this book is not intended to teach grammar. There are other books for that.

"No rules!" is hardly helpful when you have a writing task this important. Your writing can be artful, but a few simple rules won't kill you.

These three rules have helped me as a professional writer, and they'll help you crank out the type of writing that artists need to crank out:

- Get to the point
- Rewrite
- Avoid the passive voice

Get to the point

It takes practice to be concise in your writing. A sure sign of an amateur writer is someone who says the same thing three or four different ways, if they manage to construct a complete thought at all. In the same way that muddy colors can signify an amateur painter, you can easily over-blend your thoughts. The blue and the red and the green are lost, brushed back and forth into a muddy non-color.

Ernest Hemingway talked about his struggle to write "one true sentence." He wrote plain, simple sentences. One true sentence is better than a page of muddy sentences. Keep your sentences short. This forces you to get to the point. Very good writers with very good editors can pull off long sentences. For your purpose, try moving from the capital letter to the period with one thought in mind. Suppress the urge to over-explain, divert sideways, or repeat yourself. The sentences will add up, one thought at a time, each color standing by itself in a composition.

Rewrite

When I interviewed artists for this book, I met several who think they can't write because sentences don't spring fully formed from their heads. If I take one of their sentences and rewrite it, they look at me in wonder. "How did you *do* that?" Well, I rewrote it. I repeatedly rewrite my own work. Most likely, you will need to do the same with yours.

The first time I visited the studio of a "real" artist, he was painting a dinosaur. I was surprised to see him surrounded by pictures of dinosaurs: photographs of paintings and drawings done by other artists. I thought, "I could paint a dinosaur if I did that!" But I believed that would be copying or cheating. In other words, I thought a dinosaur painting sprang fully formed from a real artist's head.

Rewriting your sentences is similar to poring over visual source material. You need to do it because that's how real writers arrive at what they want to say. You sketch in words. You observe and copy form. You collect bits and pieces of things you like. You keep reworking, keep rewriting.

Avoid passive voice

Too many times, I've watched the following scene unfold at art events: a visitor approaches the art. They glance around and appear to be baffled by what they see. Then they walk over to read the artist statement and become even more baffled by *what they read.* Then they walk away.

Simple sentence construction, using active voice instead of passive voice, helps your reader understand your message.

The passive voice is not something you think about unless you're a teacher, a writer, or an editor. I don't want to hit you over the head with language rules, but I do want to discuss passive voice because you don't have that many sentences to write, and it's important to write good ones.

Passive voice is not always wrong, but again, I won't go into detailed teaching. For the sole purpose of writing about your art, I'll simplify this discussion of active vs. passive voice. You can find a grammar-savvy reader to check your work when you're done. But while you're writing and rewriting, use this pared-down explanation as a guide.

In active voice, **the subject** of the sentence—the person, place, or thing—**performs the action**. The words "I" or "my work" will be the subject of many of your sentences when you write in the active voice, because you or your work will be performing the action.

I… followed by a verb: Good
My work… followed by a verb: Good
Active voice is persuasive, clear, and direct.
Active voice: *I work in stone.* Good.
I = the subject. The artist (I) performs the action, not the stone.

Passive voice: *Stone is worked in by me.* Weak.
Passive voice: *Stone is the medium in which I work.* Weak.
Passive voice: *Stone is my preferred medium in which I have sculpted most of the pieces.* Weak.
The passive voice sounds pretentious. Just say, *I work in stone.*

Now, if you want to make "stone" the subject of the sentence, the stone should be doing the action.

Active voice: *Stone casts shadows. Stone holds water. Stone adds weight.* Good.

Passive voice also tends to create confusion, as in this example:

Passive voice: *A childhood memory was recovered of my grandfather on a New Mexico morning.* Weak.

That's confusing. Who recovered a memory? You? Why don't you say so? Was it a recent morning, or was it a morning from childhood in New Mexico?

When you string together several sentences written in passive voice, the confusion accumulates and you can really lose your reader.

Passive voice: *A childhood memory was recovered of my grandfather on a New Mexico morning. Pueblo heritage stories were told often to me by him, of the petroglyph's origins. Stone is the preferred medium in which I work, so these were beginning to inspire me.* Unclear.

Active voice: *I recovered a memory of my grandfather one morning on my trip to New Mexico. He often told me stories about his Pueblo heritage. I work in stone, so I drew inspiration from ancient petroglyphs and my grandfather's stories about their origins.* Clear.

The passive voice crops up all the time in artist statements. Could it be because artists think they're over-using the word "I," so they twist their sentences into odd formations?

You're the artist and most of the time you are performing the action, so "I" will occur several times in your artist statement. The pronoun can't be avoided. The only problem this causes is repetition: I created, I believe, I think, etc. Repetition is a much smaller problem than the strangled syntax and puzzling sentences that the passive voice can produce.

If the repetition of "I," "me," and "my" is nagging at you, here's an easy fix: start some sentences with a clause before the "I." This breaks up the rhythm and disguises the repetition.

Here are examples of clauses you can put at the beginnings of your sentences, while still remaining in the active voice:

- By the time it dries, I know...
- In order to gain a wider audience, I started...
- Because of this belief, my work became...
- Due to the accident, I knew...
- In time, my work expanded...
- Without knowing how, I thought...
- In all my work, I approach...
- With the new program, I discovered...
- After experimenting with mediums, I found...
- In the final stage, I added...

Avoiding passive voice helps you write straightforward, easy-to-digest sentences.

The grammar-checking device in Microsoft Word will often correct the passive voice for you, but don't count on it. After you write a first draft, stop and look at just this issue. Find the verb in the sentence; that's the action. Find the subject in the sentence; that's the person, place, or thing. Is the subject doing the action? Hello active voice!

✍ EXERCISE:
THE HOW AND THE WHAT

Create your content

By now you must be wondering, "So what exactly am I supposed to write about? What should my statement contain?"

You can't go wrong if you stick to the how, the what, and the why of your work.

These categories tend to overlap. *What* you made overlaps with *why* you made it and *how* you made it. There is no required order or division. You can apply a structure to your writing in a later step. For now, begin to write down thoughts that will form the basic content.

Begin with The How and The What. (In the next section, we'll work on The Why.) Read through the following How/What prompts and allow them to stir up ideas. Your responses will create the center of your statement. Rewriting is always a necessity, so remember you don't have to craft full sentences at this stage.

Prompts are meant to generate ideas. You don't have to answer every question. Which prompts apply to what you make? Which ones trigger response? Write on the blank pages in the back of the book to keep track of your notes on the How/What/Why prompts.

Prompts: The How

How did you make this?

How did you use the medium or combine mediums?

How did you physically engage in the creation?

How is it constructed?

How are you uniquely presenting the subject?

How did accidents or discoveries lead you to the finished work?

How did you choose this medium?

How did you choose this subject?

How did you decide on this direction?

How has exploration brought you to this work?

How would you like the viewer to approach the work?

How did you choose your palette?

How would you describe the contrast or continuity in the work?

How does the subject relate to the form, the form to the subject?

Prompts: The What

What is the viewer looking at?

What is it made of?

What was your process?

What does it represent?

What are you investigating?

What are you combining or breaking apart?

What was the initial inspiration and where did that lead?

What could you say that might encourage a closer look?

What are you communicating?

What story does it tell?

What did you learn while making it?

What pervades the work?

What qualities characterize the work?

What did you accomplish?

What keeps you curious/dedicated/obsessed?

What was involved? Collaboration? Skills? Tools? Travel?
Research? Technology? More than one attempt?

✍ EXERCISE: THE WHY

Expressing what you understand about your art

There is only one prompt for "The Why" in your artist statement:

Why did you make this?

To answer, you need to write about the *beliefs, emotions,* and *ideas* supporting your work. This is the heart of the matter. Art lovers search for The Why in an artist statement, but I've read statements that avoid the question completely. I encourage you to address The Why, at least briefly.

Roadblock: "I don't explain"

Maybe a part of you wants to say to the world, about your art, "Here it is. You think about it. I don't explain what I do. You figure it out."

This stance is common enough that it makes me wonder if it's just a convenient way to dodge the work of writing. Regardless of what causes the "I don't explain" attitude, it's not helpful. Patrons, curators, jurors, dealers, funders, and teachers all want to know *what you understand about your art.*

Clear writing comes from clear thinking. I've already warned you about not writing down your internal monologue: that's sinking, not thinking. Writing requires think-

ing about your work in ways that might provide the viewer with a pathway into your work. When we write with the goal of communicating with others, we are forced to untangle the knots in our thinking so that someone else can pick up the thread and follow it to our intention.

Your viewers and readers are curious about your intention. Intention is the same thing as *what you understand about your art*. Your understanding leads to the audience's understanding, just as your confusion leads to their confusion.

Roadblock: "I can't explain"

When we try to articulate the ideas behind the work, we may touch upon some strong resistance. Artists say, "I can't describe what I was thinking. I wasn't thinking about anything. That's why it's visual. It has no words."

I will not argue with that sentiment, but I will suggest an alternative. True, parts of your work cannot be described in words because words are inadequate. But other parts of the work *can* be described in words. If you struggle with expressing the thinking behind your artwork, focus your writing on the physical making of the work—the process or the development of form. You could then include something about what drives you to express yourself visually.

When your thinking is directed toward *what you understand about your art*, few artists will say, "I understand nothing about what I do." It is possible to be abstract in your ideas and still be concrete in your language.

Most artists I know have harsh inner critics. We can argue with ourselves endlessly about how good we are or aren't and why we do what we do and what for. At the very least, while writing about your work, keep your inner critic at arm's length. Instead, bring out the inner teacher/ambassador/enthusiast. Think of the person who is the best communicator you know—the best public speaker, thinker, writer, or leader—and emulate that person's level of confidence.

Self-knowledge, clear thinking, and clear expression are all related.

> Self-knowledge is not the same thing as having all the answers. It means having some awareness of what you know, what you question, and what keeps you wondering.

With that in mind, here's an exercise in directed thought to help you explore what you understand about your work.

Take notes, and keep them.

Prompt: Why did you make this?

What do you believe in?

What belief are you investigating?

How does personal belief/viewpoint/conviction come through your art?

What emotion was primary while you made this artwork? How does emotion come through the work?

What were you thinking about during the process?

What inspired this direction?

If the inspiration had no concrete logic, write about that.

And before we leave the topic of The Why, I must comment on the use of the word "spiritual" to explain art. "Spiritual" is a vague term. Used to describe what cannot be described, it means everything and nothing, and so applies to _all_ art. Find a better word to describe the spirit of your work, or don't bother. Let the viewer find the "spiritual" through his or her own experience with the visual.

How to Reference Another Artist

REFERENCING THE WORK OF ANOTHER ARTIST IN YOUR writing is tricky business. If a particular artist was a profound influence, you may feel the need to acknowledge him or her. This is understandable. To do it successfully, though, the writing must focus attention on your work, not divert attention away from it.

Some things to avoid:

- Name dropping: *"My mentor, Pablo Threshold, once told me that process is everything."*

How does this statement relate to what your audience is looking at? A better approach would be:

"I am primarily interested in process. This is something I learned—to let go of considered outcome—from my mentor, Pablo Threshold."

This sentence incorporates the reference, but draws attention to what you do.

- Generalized, sweeping references: *"The photography of Cindy Sherman strongly influenced this series."*

Your audience may not be familiar with the work of Cindy Sherman, so don't make that assumption. Even if they're Cindy Sherman scholars, you haven't told them what work of hers you're talking about and what exactly you found influential.

- Grandiose proclamations: *"I took the work of Cindy Sherman a step further."*

Never step into the role of art historian or art critic; it hurts more than it helps.

Cindy Sherman, as well as every other well-documented artist, has produced a lot of work and there are many interpretations of her work. Be specific. Write about your understanding of her work, how you found inspiration, or what aspect of her art directly affected your own.

"In the way that Cindy Sherman's early work points out the narcissism fueled by media images, my photography explores the effects of that narcissism and how it impacts young girls."

There we go! This sentence makes a clear connection between your work and your artistic influence. Someone who has never heard of Cindy Sherman can understand how your art connects to hers. And the reader's focus is placed on the piece in front of them—your piece.

Art history always builds on itself, and there's a vast world of artwork that preceded yours. It's best to let your audience make their own connections. They'll feel smarter.

They'll have something to discuss. Answering the question, "Where did this come from?" to the point of mentioning other artists is not usually necessary.

There are always exceptions and I'm not asking you to follow a rule. Ask yourself: "Do I need to provide another artist's name in order for this work to be better understood? If not, do I want to do it anyway?" If the answer is yes, provide the name and the context as a way to help people look more closely at your work.

"I take inspiration from Zen gardens, and appreciate how Noguchi finds presence in the Japanese concept of 'ma' or negative space: these ideas inform the aesthetic of my installation."

This sentence accomplishes three things that make it a successful reference to another artist:

- It evokes images and connections even if the audience is unfamiliar with the referenced artist.

- It mentions how you interpret the artist or what you found inspiring.

- It draws attention back to your work, with added interest for the audience.

✍ EXERCISE: DEVELOP SENTENCES

Fill-in-the-blanks

The following section of fill-in-the-blanks is designed to help you turn your thoughts into sentences. Use these fill-in exercises to start building cohesive ideas and sentences. Let this create your success in conquering the blank page, the blank screen, the big blank.

You can take the fill-in-the-blanks directly from this exercise and use them in your artist statement. That is, after you fill them in! No two artists will complete these sentences in exactly the same way.

Choose any or all. Try out different ideas. Keep your notes and examine all of this process; it will help you arrive at what you truly want to say.

Fill-in-the-blank #1

I work in (form/theme/medium) because it allows me to (action/expression).

EXAMPLES OF #1:

I work in landscape because it allows me to experiment with style and palette.

I work in collage because it allows me to highlight contradictions.

Fill-in-the-blank #2

I (verb) the viewer in order to (state your intention).

EXAMPLES OF #2:

I invite the viewer in order to tell them a story about the mystery in the familiar.

I agitate the viewer in order to break down walls between them and my subject matter: the homeless in America.

✍ _____

Fill-in-the-blank #3

I created (the work) to express my (belief/emotion/ idea) concerning/and (the situation/inspiration).

EXAMPLES OF #3:

I created these images to express my frustration and anger concerning our city's disregard for the homeless.

I created this series to express my fascination with landscape and how forms evoke emotions.

✍ _____

Fill-in-the-blank #4

(Clearly describe a particular piece in the show) is based on (reference or experience).

EXAMPLE OF #4:

The small glass sculpture of the clock is based on the time I spent recovering in the hospital.

✎ _____

More fill-in-the-blanks

I am drawn to the subject of _____ because _____

In the process of creating this work, _____

I want my viewer to _____

I discovered that my approach needed to be _____

I find inspiration _____

_____ is at the center of my art.

I don't _____ Instead, I _____

My work is a combination of _____ and _____

To me, the most important thing is _____

I make connections between _____ and _____

To me, this represents _____

I was thinking about _____ and I created _____

Three Ways to Structure Your Statement

There is no prescribed structure for writing an artist statement. This is good news because it gives you a free hand, and bad news because it offers endless possibilities.

Again, you must consider your audience, so it's important to apply a structure of some kind to your writing. Without structure, the reader has an unmet expectation. They want to be led somewhere but find themselves arriving nowhere.

Here are three different structures you can apply to your statement.

Structure One
Storytelling: beginning, middle and end

The structure I apply to almost everything I write is this: beginning, middle, end. I know it sounds ridiculously simple, but it works for everything from writing a thank-

you note to writing a speech. If you provide a beginning, middle, and end for your audience, they tend to pay attention. They feel assured that you will lead their attention down a logical path with an eventual conclusion.

For example, I've read quite a few artist statements that start with something like,

"I've been making art since I was a kid."

The sentence *sounds* like a beginning. It has an introductory quality that holds promise of connecting to something later on. But does it go anywhere? Without connection it just stands alone as a biographical blip. This is an opening sentence, but it's not a beginning.

If the opening sentence is about childhood, make it a true beginning and continue to talk about how childhood art connects to what the audience is seeing now. You could also come back around to childhood at the end.

The simplest way to write an *end* is to write a last sentence that relates back to the first sentences.

An important note: Unless details of your life story relate specifically to the art in front of the viewer, leave them out of your statement. Write a separate bio. (See page 90.)

Most of the time, your statement will be no longer than one page, or one to five paragraphs. You can write three paragraphs as a successive beginning, middle, and end of your statement, or write one paragraph as a stand-alone containing a beginning, middle, and end. You decide how to get there, just weed-whack your way through the over-

growth of random thought. Write in a clear path, one concept at a time.

Introduction \longrightarrow Discussion \longrightarrow Concluding thought

Here's a fictional example of beginning-middle-end structure:

> *I don't use color in my work because I'm not done exploring gray. An achromatic palette leads me to work in mixed media. The blackest blacks and the whitest whites are ink and acrylic paint. Grays are pencil, charcoal, watercolor and pastel. Scientists tell us that black is the absence of all colors and white is the presence of all colors. So I consider gray to be what exists between absence and presence.*
>
> *That idea works with my preferred subject—the human face. I draw faces enlarged to the point where they resemble topographical maps, rendering a geography of scars and pores and idiosyncratic identifiers. Yet the viewer cannot identify an individual.*
>
> *I like the paradox of the close-up that looks like a distant view. It's the way we see most of the people who surround us: they are right in front of us but we can't truly tell who they are. Or we don't care. They exist in the gray zone, between absence and presence.*

You might tell a story with this structure. People love a story. Stories have a built-in *beginning, middle, and end*, with one idea connecting to the next idea. Here's a good

fictional example of a storytelling-structure artist statement, where the beginning, middle, and end are all contained in one paragraph. Notice how the story manages to neatly contain The How, The What, and The Why. It also circles back, with the last sentence relating to the first sentence.

There was a big storm and my neighbor's 75-year-old walnut tree was split in half by lightning. I offered to help him chop and haul it if he would give me a big piece to carve. These sculptures are made from a section of the trunk that cured in my shop for 5 years before I figured out what I wanted to do with it. I looked at that wood every day. It finally occurred to me to keep the side with char left by the lightning strike, and expand on the theme of burned wood in the supporting frames. For me, this series is about both destruction and preservation. It's about what we choose to keep after going through trauma.

Structure Two
Medium, process, understanding

Divide your statement into three sections, or possibly three paragraphs. The first discusses the **medium**, both what the work is made of and the physical description of what the audience is seeing. The second section describes **process,** or how you arrived at the finished work. The third section discusses your **understanding** of the work.

Now let's look at a fictional example of medium/process/understanding structure:

In 'Waiting Room,' a series of oil-on-wood paintings, I depict interior spaces that contain atmospheric disturbances. I present a fixed view of a room, as if the viewer is standing in the doorway, looking in. Each painting changes slightly as the scene within the room changes. The rooms do not contain people, only the things that people collect.

First I build models of the rooms from cardboard, found objects, and craft-store items. I photograph the models with a stationary camera and paint from the photos. I manipulate the lighting and the objects inside the model room. The blurs in photos interest me greatly. So I often incorporate things that move, like a dollhouse rocking chair and a revolving miniature Christmas tree, to create more blurs which I then emphasize in paint.

My paintings contain both static and dynamic elements. Everything changes, everything passes. Each phase is worth examining. Like transitory mental states, I explore the progression of experience within a fixed field of vision.

The common advice to grab attention with a great opening sentence won't work in this structure. Here, you'll open with something like "made of Styrofoam and paint."

This is fine—it works because you'll be answering one of the viewer's first questions, "what is this made of?" If you use the medium/process/understanding structure, write a strong and attention-getting *last* sentence.

Structure Three
Field notes

Now I'd like to introduce a structure, based on the writing style of photographer Dorothea Lange, which differs from the typical one-paragraph or one-page artist statement. Lange documented her work very systematically: she wrote a "General Caption" for each setting or series, and brief "Field Notes" to accompany each individual image. It may be a method that works for you.

Her spare notes are sometimes incomplete sentences, yet they very effectively pull the viewer into the image. Her words don't just describe the photograph; they somehow manage to enhance its impact. When I attended a show of her work, I was struck by the gallery visitors' intense interest in her written words. The viewers' eyes constantly moved back and forth between the photographs and the text. Clearly, Lange had written something beyond mere captions.

Dorothea Lange's gift for combining text and image is explored in-depth in the excellent book *Daring to Look: Dorothea Lange's Photographs and Reports from the Field* by Anne Whiston Spirn.

In the following examples, I've included a shortened

version of the "General Caption" but the text of the "Field Notes" is transcribed in its entirety. I want to show you how just a few words can convey so much about an image.

> **General Caption** *No. 49*
> *Date: October 20-23, 1939*
> *Place: Bonner and Boundary Counties, Northern Idaho*
> *Subject: Recent settlement of cutover lands in northern Idaho*
> *…This is a logged-off region, the big lumber mills are abandoned…The majority of new settlers of northern Idaho are land hungry farmers from the drought stricken areas of the Northern Plains states…Practically all the land available for settlement is privately owned, with lumber companies holding the bulk of it. The price of the land appears low. Many contracted for land they had never seen. They have bought raw lands, partly developed farms, which were abandoned by previous settlers. Many come with little cash, many come with no cash, and no equipment…The severest problem which newcomers in this area have to face is that of getting enough land cleared to support a farming enterprise because of the difficulties involved in getting rid of stumps.*

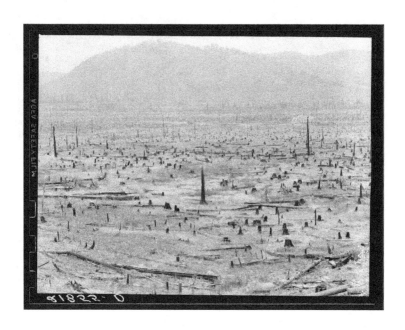

*"Field Note" 129. October 22, 1939. Priest River Penin-
sula, Bonner County, Idaho.*

*Priest River Valley, where new settlers grow hay between
the stumps.*

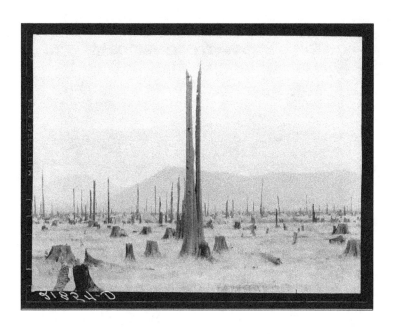

"Field Note" 130. October 22, 1939. Priest River Peninsula, Bonner County, Idaho.

Shows character of land which new settlers are buying in the Priest River Valley.

"Field Note" 131. October 22, 1939. Priest River Peninsula, Bonner County, Idaho. This farm has been occupied by four different families since 1936:
 Claude Sargeant '36-37 failed
 Lenny Davis '38 failed
 Roy Silton '38-39 failed
 Davy Walker '39 failed
 The soil is sandy and the effort of clearing has been wasted.

These photographs tell a compelling story, yet without the accompanying text, the typical viewer would think, "Nice stumps," and move on. Lange used words to create curiosity, to share information, to provoke closer examination of subject and form. In other words, she wrote a very successful artist statement, even if she didn't call it that.

> An artist statement's success is defined by its ability to provoke closer examination of the artwork.

Dorothea Lange did not tell the audience how to feel. She led them to examine the image, but she did not lead them to conclusions. Her field notes were simple, but they never pointed out the obvious. Let your "Field Notes" cause the audience to pause and let your art do the rest.

The writing structure of "Field Notes" will obviously work well for documentary photography, but can be applied to a series of any kind. Start with a paragraph to describe "where you are," so to speak, or what you're exploring (what Lange called the General Caption). Then add notes about the individual pieces. Lead the audience piece by piece through your show, or use this structure to accompany digital images you submit for review.

Now you have three different structures to choose from. Or you could take some advice from all three and blend them. You will distinguish yourself when you write something cohesive and structured. Tell a story or provide a logical path. The structure of your statement is in the service of its intended goal: to lead the reader somewhere, and always lead them back to what they are seeing.

Word Coffee

For a few years I worked as a copywriter, writing hundreds of radio and TV commercials. The deadlines came fast, so I learned to follow this essential self-direction: don't over-think, just write!

When I was assigned to write on a subject about which I knew nothing—like auto body repair—I'd evade panic by flipping through the just-in-case copywriting book I kept in my desk. The book contained nothing but "ad-speak," listing hundreds of words and phrases commonly used in commercials. It was like chugging a big cup of word coffee. I'd fill up my head with ad-speak, and commercial copy would flow through the keyboard.

A radio commercial doesn't need to be original and brilliant, and neither does an artist statement. Both serve to "get people through the door," as they say in advertising. You might take offense at this analogy, but your writing

does not require the profundity of your art. The writing serves an applied purpose.

Plus I'm trying to get you to loosen up! You've done the hard part. You've made the art. Stop over-thinking and dive in.

It may help you to fill up on art-word coffee, especially if you get stuck. The following pages will provide you with a list of potent words and energetic verbs.

Let's refer once again to the definition of an artist statement:

*An artist statement is a concise **arrangement of words** that acts as a bridge to connect your audience to your art.*

Everyone approaches writing differently, and you need to find a way that works for you. Don't just stare at a page or a screen. Gulp some word coffee. Fill up on descriptive words and phrases. Arrange them. Rearrange them. Write them on pieces of paper and toss them up in the air. I'm not encouraging art-babble, but word coffee just might jolt you out of a non-productive stupor and inspire actual sentences.

Useful phrases and words

An integral part of …
The foundation of …
I value …
My process …
In the spirit of …
I am intrigued by …

Provide clues ...

Ask questions about ...

My technique developed ...

My observation of ...

What interests me about ...

My vision ...

Making connections between ...

Reflect my way of ...

Reference my experience of ...

Bring focus to ...

The question I ask myself ...

Rooted in ...

I attempt to make things look as if ...

Articulate	Allows
Absolute	Amplify
Absurd	Animates
Accelerate	Appears
Activate	Arrange
Adapt	Articulate
Adaptation	Assemble
Adhere	Atmosphere
Advance	Balance
Aesthetic	Belong
Affords	Bewildering
Aggressive	Blend
Alerts	Brushwork

Capture

Catalyze

Challenge

Chiaroscuro

Circular

Common

Crystallize

Complementary

Composition

Conception

Coincide

Consciousness

Consider

Constrict

Construct

Contains

Contemplate

Contorted

Contradict

Contrary

Converge

Crude

Cultivate

Declare

Define

Defies

Degree

Delicate

Demands

Demarcation

Depth

Devise

Dimension

Direction

Directs

Discover

Discovery

Disparate

Dissolves

Distinct

Dramatic

Dynamic

Edges

Embrace

Emerges

Exaggerate

Endeavor

Energy

Engage

Enlarge

Evoke

Examine

Execute

Experiment

Externalizing	Intentional
Extravagant	Interface
Exude	Introspective
Flinging	Invent
Force	Investigate
Form	Juxtapose
Formal	Kinesthetic
Formidable	Knowable
Formula	Layer
Fracture	Level
Fragmented	Line
Freedom	Linear
Fundamental	Literal
Gestural	Loose
Grasp	Magnify
Happenstance	Markers
Harmonious	Materialize
Hue	Mechanism
Identity	Merges
Illusion	Message
Image	Minimize
Important	Modified
Improbable	Movement
Improvisational	Multi-directional
In-depth	Mythology
Insight	Non-objective
Instinct	Notably

Novel	Prevalent
Nuance	Problem
Objective	Quasi-
Oblique	Question
Odd	Random
Organic	Redefine
Outright	Reduce
Overlap	Render
Paced	Regarded
Painterly	Reinforce
Pairing	Relationship
Palette	Requires
Particular	Research
Pattern	Resolve
Perpetuate	Resonate
Perspective	Rest
Pervasive	Reveal
Persuasive	Reverses
Pictorial	Rewarding
Posing	Rich
Positioned	Schematic
Potent	Semi-
Power	Sensation
Powerfully	Senses
Principles	Shades
Precision	Shadows
Presence	Shapes

Shift	Synthetic
Shock	Tension
Significance	Tight
Signifies	Traces
Similar	Traditional
Simplify	Transcends
Singular	Transform
Spins	Transmit
Stabilize	Transpose
Strength	Underlying
Strike	Uniformly
Strikingly	Unintentional
Subliminal	Unsettle
Subsequent	Velocity
Substance	Veracity
Subtle	Vulnerable
Supple	Wielding
Surprising	Yielding

As you become more in tune with the power of words, add your favorites to this list. Read eloquent art writers for inspiration. Take note of the words and phrases used by any good writer. Like collecting collage elements, store away pieces that might be useful later.

✍ Exercise:
Write a First Draft

How you use this book is up to you—approach the information in any order you wish.

If you prefer a step-by-step method, here is a suggested plan of action based on what we've covered so far.

Get ready to dedicate some focused time. Put pen to paper, fingers to keyboard, pencil to sketchbook. Time to Art-Write!

- Do your thinking. Jot down notes from anything you've read in *Art-Write* that provokes thought.

- Review all the How/What/Why prompts (pg 30). Choose the ones that spark you to describe your work. Answer the questions.

- Review the fill-in-the-blanks (pg 43) and identify the sentences that may apply to what you have to say. Fill them in.

- Using what you've accomplished in steps 2 and 3, write several full sentences that might be keepers; sentences that tell the truth. They don't have to be sequenced or arranged yet. Just write a few good sentences.

- Review the chapter on structure (pg 47) and begin to arrange sentences.

- Write a draft artist statement, start to finish. Rough it in. Perfection not required.

- Review the chapter on audience (pg 16).

- Review the three rules (pg 23).

- Rewrite.

- Now let it sit. Come back to your statement a little later with fresh eyes.

- Check out Word Coffee (pg 58) and improve your vocabulary. Remove generalized, well-worn phrases and replace them with specifics.

- Continue to review the steps and rewrite until you're ready to hand over your statement to a trusted reader.

More tips ahead.

Three Ways Your Friends Can Help

IF YOU HAVE TROUBLE ASKING FOR HELP, YOU'LL HAVE TO get over it. There are times when you need a sounding board, and you probably have friends or other artists (or both) who are willing to help you. Below are three ways you can ask friends to help you out with your writing project.

If you are at a loss for written words, record a conversation

It's surprising how conversations can help you gather things to say, especially during times when you're searching for words. You may be more likely to express yourself well while talking, and the person you are conversing with may come up with insights you hadn't considered. Instead of grasping for a pen and wondering, "Oh wow, what did I/he/she just say?" set up a simple way to record a conversation. Use an app, buy or borrow a digital recorder. You can ask a friend to prompt you with ideas from this book.

Set up a casual interview, or just talk to each other about what you've created.

Questions coming from another viewpoint are valuable; those are the questions that encourage you to say something beyond your usual cache of wisdom. Experiment with the interview process, record conversations, and see what happens.

> Interviews generate most of the quotes from noted artists. You may find exactly what you want to say by actually *saying* it.

Writing in the third person

So far I've discussed writing about your art in the first person. This is the best way to personalize your statement, and most often it is necessary. There are times, though, when it sounds more convincing to have someone else speak about you, and then you'll want to write in the third person. Your bio is a good example of this.

In the copy writing for your website or brochure, it sounds good to include both writing *from* you and writing *about* you. You might be able to write in the third person on your own, changing each *I /my* to *she/her* or *he/his*, but it's awkward to attempt this alone because it feels disingenuous. Another voice can make it shine, so enlist the help of a professional writer or a skilled friend. And while you're at it...

Ask an editor or intelligent reader to review your statement

No matter how proficient a writer you are, you must have someone look over your writing before submitting it. At minimum, you need someone to check spelling, grammar, and punctuation. A good editor does more than that. They apply a different logic, and point out where sentences could be moved or where ideas need to be clarified.

This whole endeavor is about perception, in more ways than one. How do you want to be perceived? Observant and smart? Then don't skip this important step! Ask an engaged reader. Pay an editor, ask a favor, or make a trade—just make sure someone else reads over your work before you submit it.

> Trade or paid—get an editor!

PART TWO

WRITE TO BUILD AND MARKET YOUR ART CAREER

✍ Exercise:
The Handshake Speech

Now that you've done some writing and had an opportunity to think about your art and your role as an artist, I challenge you to describe your work as concisely as possible.

Word subtraction

How many of these blanks can you fill in? How briefly can you describe your work?

My art is about _____

In five words: My art is about _____

Four: My art is about _____

Three: My art is about _____

Two: My art is about _____

One: My art is about_____

Finding just a few well-chosen words is the perfect way to arrive at what you will *say out loud about yourself.* Distill a description of what you do, reduce it down as far as possible. This is a way of being considerate to your listeners—because they can always ask more questions—and of making you sound more confident.

You will often act as your own ambassador or agent. Speak up. Confidence and enthusiasm are the very best

self-promotion tools, so prepare something brief to say about your work and yourself.

> The way you speak about yourself and your work sends people to the intended destination: your art.

In business, this is called your "elevator speech." I don't care for that term because it makes me envision people packed into an elevator, all of them staring forward and talking about themselves. So let's call it the handshake speech, which implies that some kind of connection will take place. Imagine someone reaching out his or her hand to you—a stranger, an art-worldling, a gallery owner, a collector. Will you be ready to introduce yourself?

This is a performance. Write your lines. Know your lines!

Hi, my name is _____ I'm an artist

I work in (mediums)_____

My art is about _____

I'm working on _____

I'm based/my studio is _____

You can see my work (online/gallery)_____

This is a good time to hand them a business card, and what's really important is to be prepared with a question *for them*. Asking the other person a question helps to bridge the weird pause at the end of your handshake

speech. Try, "Are you an artist?" because non-artists like that question, and it's a good lead-in for conversation.

Far too many times, I've seen my artist friends get tongue-tied and reticent when asked what they do. Frankly, my dears, this does not work. You have an occupation just like everyone else. And your occupation requires self-promotion. Imagine asking a plumber what they do and hearing the answer, "Uh, I plumb. Pipes, primarily. I can connect them. Basically, um, water transportation. Systematically." Would you hire this person? Would you want to keep talking to them?

> In the contemporary art scene, art and artist are packaged together. If you're getting queasy right now from all the sell-speak, remember: your art is the treasure and everything else is just the map.

I urge you to create your handshake speech and rehearse it out loud. No matter how awkward this may feel right now, it will be far more awkward in social settings if words fail you. Don't miss opportunities to make connections and sales because you weren't prepared with a few short sentences. Take what you write and put it to good use off the page.

An Artist Art-Writes

Betsy Wolfston

IN THE FOLLOWING SECTION, I WILL SHOW YOU HOW YOU can organize your art-writing into categories and recycle the content for different opportunities. I developed this idea with artist Betsy Wolfston.

Betsy is a ceramicist based in Eugene, Oregon. Her public sculptures enhance the artscape of Eugene from the University of Oregon Law Library to the train station. Through gallery shows, teaching, public art commissions, private commissions, and open studio sales, Betsy has supported herself with her artwork for twenty years.

Betsy doesn't like to write. She thinks deeply about her artwork, as evidenced in the work itself, but writing about her art causes her self-doubt and bewilderment. She came to me for writing help. At our first meeting, Betsy laid out blank forms and proposal documents—all requiring writ-

ing. She was applying for a variety of opportunities from several different arts organizations.

Betsy had written a few paragraphs about her work that loosely served as her artist statement. She wasn't happy with what she'd written and was challenged to write more. The task wasn't just a writing assignment; filling out these forms and completing the proposals held the potential to advance her career and pay the bills. This writing job struck me as confusing, and I'm someone who likes to write! I could only imagine how overwhelming it felt to someone who dislikes writing.

Here's a sampling of the questions, mixed together from several funding sources to give you an overview:

1. Describe the specific discipline you work within.
2. How has your work evolved over the last 5-10 years?
3. How does your art reflect your values and concerns?
4. Why is this opportunity needed at this stage of your career?
5. What is the meaning and intent of your work?
6. Why and how did you select this particular consultancy/activity/opportunity/event?
7. Describe how the project will artistically enhance the goals of the organization.
8. Describe any previous teaching experience you've had and the unique qualities you bring to the classroom.

Together, Betsy and I worked to pull together her artist statement, but it wasn't enough to cover all the questions asked of her in these forms and applications. We decided to identify categories that define her as an artist and relate to question from the douments. I call them bins for sentence recycling.

Now that Betsy has these bins, she continually refers back to them. They serve as a prime resource when she needs to write about her artwork. This system allows her to easily recycle the sentences she likes.

Here are Betsy Wolfston's bins, or career categories. They are edited and structured, but yours do not need to be this polished.

Intent

Applies to questions 2, 3, 5, and 7

During my twenty-year development as an artist, I have studied how to have conversations that facilitate understanding; dialogue that leads to truly seeing someone else's point of view. My artwork incorporates that study. I'm interested in allowing the viewer to unmask and consider the possibility of exchange between my point of view and their own. My art is my own unmasking. Like many artists, I want to communicate and I want to affect change in the world. My work is subtle. I don't shout. In both medium and metaphor, I use layers of content to tell stories of the human condition in its damaged perfection. Different individuals discover the layers in different ways. I am

purposefully open to possibilities and true to my values of revering life, peace, compassion, and authentic presence.

Medium

Applies to questions 1 and 6

I am a ceramic artist and I primarily hand-build. All of my pieces are high-fire stoneware. Much of my current work is wall-mounted bas-relief varying greatly in size, from pieces 3"x 3" to large-scale installations. My work consists of images, shapes, and text that together tell a story. I feel I have found my way to make my mark in the material. Part of making my mark is to continue exploring what the medium allows. For site-specific projects, I've combined my ceramic pieces with other mediums by collaborating with artists working in metal, glass, and wood.

Development

Applies to questions 2, 4, 6, and 7

As I enter the mature phase of my artistic life, my attention span is longer. I know more, so I can combine more. Supporting myself solely through my art for two decades, I've learned to find contentment in my productivity and capable continuance. Woofworks Studio has been my private production space since 1993, part of the 2ⁿᵈ & Blair Artists Studios in Eugene, Oregon. Gallery sales, public art projects, teaching, private commissions, craft fairs, and open studio sales provide the streams of revenue sustaining my career. My development as an artist is rooted in my

belief that there is something more to say, and commissioned work often inspires me. I enjoy researching site-specific projects, learning how the space is used and who uses it. I welcome the challenges that push me to innovate, while deepening my ability to interpret what is needed.

Teaching

Applies to questions 3 and 8

I feel the most valuable thing I can share with young people is the example I present as a resourceful problem-solver. In addition to my enthusiasm for guiding student projects, I enjoy teaching young people how to tap into their own inner resourcefulness. I believe that art class is not only applicable to every other school subject; it is a keystone to developing a sane human being. Often I find that I am the first artist my students have ever met. When, in their presence, I mess something up and then fix it, they are wowed by the example—I didn't stop, I changed it into something else! My students may not follow my career path, but I can help them become aware of creative approaches and have a creative experience. I introduce the thinking style of, "what if?" My examples as an innovative thinker help young people become aware of possibilities. I find this very rewarding.

Travel

Applies to questions 2, 3, 5 and 7

Research is vital to my work and I remain curious. I

tell stories in clay, and travel provides fresh content and deeper meaning to my work. My work consists of layer upon layer of meaning, and every experience multiplies the dimensions of the narrative.

Here, insert specific examples of travel and resultant shows/ work relevant to the proposal, such as: My show, "Arms," at Butters Gallery (Portland, OR) in 2008, was inspired by my trip to Syria. I collaborated with an Iraqi refugee whose art was on display at the UN headquarters in Damascus. I arrived with the intent of finding an artist who would be willing to collaborate with me, so I sought him out after seeing his work. I brought along artwork I'd started on scratch clayboard and left those pieces with him to finish. The title "Arms" refers to several layers of meaning: arms as weapons, arms as reaching out to another culture, and coats-of-arms as symbols of clan protection. The show brought forward cross-cultural awareness during a time of war.

THE ARTIST STATEMENT, AS THE FOUNDATION FOR ALL art-writing, overlaps with the sentence-recycling bins. As in Wolfston's example, sentences can be repeated word for word:

Betsy Wolfston artist statement

I am a ceramic artist and I primarily hand-build. My pieces are high-fire stoneware combining images, forms, and text. Much of my current work is wall-

mounted bas-relief varying greatly in size, from pieces 3"x 3" to large-scale installations. During my twenty-year development as an artist, I have remained purposefully open to possibilities and true to my values of revering life, peace, compassion, and authentic presence. In both medium and metaphor, I use layers of content that together tell a story of the human condition in its damaged perfection. The work is subtle. I don't shout. I have studied how to have conversations that facilitate understanding; dialogue that leads to truly seeing someone else's point of view. My artwork incorporates that study. I'm interested in allowing the viewer to unmask and consider the possibility of exchange between my point of view and their own. My art is my own unmasking.

To review, here are five suggested bins for sentence recycling:

- Intent
- Medium
- Development
- Teaching
- Travel

Create categories that are tailored specifically to your focus and goals. More suggestions:

- Technology
- Process
- Collaboration

- Research
- Influences
- Residencies
- Social/Political/Cultural/Biographical Motivations

Organizing your sentence-recycling bins has great potential for long-term payoff. With each opportunity in the arts, you'll be asked to write about the meaning and scope of your work. Fortunately for you, the answers don't have to be lengthy; you only need a few good sentences that can be fine-tuned to answer specific questions. That's why it's important to maintain a file of art writing. The writing you produce from *Art-Write* exercises is durable; you can recycle and repurpose it over a long period of time.

This system serves to break down and organize how you define yourself as an artist. Approach this one step at a time. Begin by saving good ideas, phrases, and sentences. Add structure later. Betsy and I started by saving some of the sentences edited out of her final artist statement.

Start by considering:

- What opportunities are in front of you?
- What can you learn by reading artist-submission forms and requirements?

When you come across a question not answered by your artist statement alone, you've identified a bin. You make and fill buckets of content.

LifeForce, 10' H x 5.5' W, Stoneware, Glaze, 18kt Gold, Wood

Wolfston was awarded this public art project now installed at Lane Community College, Eugene, OR.

Interview with artist Betsy Wolfston

Art-Write: Talk about how you use the sentence-recycling system for your writing.

BW: Well, recently I got a notice about a book coming out on 100 Northwest artists, and I was asked to be in it. Artists all have to submit some writing about our work. So I reread my categories and thought, 'Oh yeah, that's how I talk about myself!' I need my memory refreshed because I just don't walk around thinking about myself in that way. I'm usually thinking about my work or the next idea. When I have to fill out some form, the system is like having a toolbox. It's easy to work with. There are some good sentences in there and I'm able to weave them into the next thing I need to write.

AW: Have you missed an opportunity in the past because you didn't want to write about your work?

BW: Yeah, a few years ago I was nominated for the Portland Art Museum Contemporary Art Award. I didn't submit. The museum wanted a lengthy reply and I didn't have any writing done. I froze.

AW: Why did you freeze?

BW: Because I'm an introvert. A lot of artists are. But I guess this whole idea of art being driven by personality is just the way it is. People want you to represent yourself. Nobody is playing a mean trick on you. You just have to do it. Like homework, you just have to do it. I'm reading a book right now on how to handle being an introvert.

AW: What does it say?

BW: It says introverts and extroverts really like each other.

AW: That's good news. See, you can get out there and mix with extroverts.

BW: (laughs) I know. I just hate it when artists sound arrogant.

AW: Do you have a handshake speech?

BW: I had one and then I got tired of it. It made me feel like, oh god, here comes Betsy Wolfston again. You're right, though, I need a new one. I look at it like this; one of my roles is to help the arts, to be an arts advocate. If I don't talk about art and do it well, I'm no help.

Filling Out Forms and Writing Proposals

Note: This advice is also relevant to finding a gallery, though it focuses on funding and scholarship opportunities. Thoroughly research the gallery you want and always follow their particular guidelines for submission.

For funding and acceptance of all kinds, you'll find the questions are different, but the root of the questions is similar. Keep this in mind when you decide it's time to tailor your writing to apply for a grant, public art commission, school, or award.

You can figure out what most funders, granters, and art gatekeepers really want by considering these three tips:

1. They want the chosen art to fit *their* purposes for *their* project/program/organization, and they seek assurance that the artist understands the particular opportunity.

2. They want the chosen artist to be reliable, trustworthy, and skilled enough to accomplish what they

propose to accomplish.

3. They don't want to be embarrassed by their choice of artist.

Let's examine these three ideas. For the artist, career leaps can be nerve-wracking. When applying for a grant or commission, you have to describe something you haven't yet produced. For opportunities such as scholarships and residencies, you wonder if it will be a good fit and how your life will change if it works out. You envision receiving acceptance and money, or rejection and no money, and your mind starts traveling where it will. It's easy to get caught up in your own imagination and minimize the importance of considering who is asking these questions and why.

1. They want the chosen art to fit *their* purposes for *their* project/program/organization, and they seek assurance that the artist understands the particular opportunity they offer.

To successfully address Tip #1, pay close attention to their goals, mission, and intentions. Do your research about the history of the organization; it will give you some useful vocabulary. They don't know exactly what they're looking for because the art doesn't exist yet. Their attempt to explain what they want is expressed in the project description and *in the questions*. Carefully read and reread all the materials provided, especially the questions. Echo back parts of the project description, such as, "You are seeking _____ and I propose to provide _____."

2. They want the chosen artist to be reliable, trustworthy, and skilled enough to accomplish what they propose to accomplish.

To successfully address Tip #2, you must "play up" your responsible nature. Write about projects you have successfully completed, goals you've achieved, and budgets you've adhered to. This is the place to boast about dedication and accomplishment. If it suits the purpose, mention parts of your life outside of the art realm. For example, you could elaborate on a non-arts-related job where you uphold a budget, meet deadlines, or fulfill the expectations of clients. In every case, remember to highlight your art skills, your dedication to your work, and your proven ability to complete projects.

3. They don't want to be embarrassed by their choice of artist.

To successfully address Tip #3, imagine a selection committee's worst nightmare—facing a room of angry elected officials, trustees, or members of the public after all the funds have been spent on a collapsing structure. Tip #3 may be the most important of all. You want to assure the people reading your application in every way possible that you are *the* person, *the* artist they are looking for. Write to gain their trust. Emphasize your concern for their needs and requirements.

Filling out forms and answering lots of questions about your art takes confidence and patience. It's work. But the

effort you apply to writing your artist statement and using the exercises in this book will take you a long way down the path.

In the process of absorbing *Art-Write* and crafting your statement, you clarify concepts, equip yourself with useful definitions, find words that feel correct and authentic, and store away the defining sentences you need. You've already begun to art-write.

Bio, Cover Letter, and Resumé

THREE MORE PIECES OF ART-WRITING WILL BE VERY USEFUL, SO let's get prepared to write your bio, cover letter, and resumé. Not to worry, this will not require the intellectual effort of writing an artist statement.

The artist's bio

A bio—or biography—is different and separate from an artist's statement. The details of your life do not belong in your statement unless your art is directly connected to a life event. The type of artist statement that is autobiographical—used to describe an autobiographical show—can be very compelling. But these types of shows are the exception. In other cases, the writing becomes too broad and rambling if you attempt to merge your life story with the story of your artwork.

Typically structured in narrative progression from past to present, your bio is written in the third person. It in-

cludes events relevant to your development as an artist; details such as where you come from, where you're based, influences, environment, and training. The bio mentions career highlights, but the small details of a resumé do not belong.

> Your statement is an introduction to your work: "People, meet my art." A bio is an introduction to you: "People, meet the artist."

Include a bio along with your artist statement even if it's not requested specifically, because a bio adds a personal dimension to your work.

Here's an all-too-typical bio (fictional):

Ken Grant was raised in Manchester, Vermont, and received his MFA from Vermont College of Fine Arts. He has exhibited his paintings in over 20 group shows and 10 solo shows across the United States and Canada. Ken resides in New Hampshire and teaches painting at Chester College of New England.

While there's nothing technically wrong with this bio, we didn't learn anything about Ken we couldn't have learned from his resumé; his bio is dry and corporate. An artist bio gives a glimpse of the personality behind the work. Go ahead and reveal a unique, insightful, personal, or humorous detail about your life. It's a great way to draw your audience in and make them more receptive to your work.

You have freedom to express yourself in a bio; just don't stray from the subject of your artistic development. Craft a story. You can omit life events and highlight whatever details you want. If your bio is longer than one paragraph, make sure it reads like a story and not a list of accomplishments. Convey something of who you are as well as what you've done.

Here's a livelier example (fictional):

Nina Suarez enjoys telling people she once worked as a portrait artist in Disneyland. She held the job for one summer after she dropped out of UC Santa Barbara. Suarez went on to develop her signature portrait style after she moved to Oakland, California, in 2002. The politically motivated community of Eastside Arts Alliance provided her with encouragement to pursue her vision. Her "Brainstorm" portrait series is now in the collections of the Oakland Museum of California. Suarez serves as a volunteer teacher for youth arts programs in the San Francisco Bay Area and remains active in social justice causes.

Cover letter

E-mail has replaced the traditional printed cover letter in many cases. Even so, an e-mailed cover letter or inquiry should retain the sense of a formal, business-like introduction. Use business stationery for this purpose or design a simple letterhead. The cover letter changes slightly for

each opportunity but retains its basic form. You'll always want to highlight what you can do for them, not what they can do for you.

Keep it short. People reading your cover letter have read hundreds of cover letters. They'll appreciate that you observed the formality and presented yourself professionally, then skim your sentences looking for a few key points.

Using our trusty beginning-middle-end structure, here is the basic content and outline:

Letterhead with your contact information. For e-mail, use a full signature containing all your contact information.

Date

Hello (insert a person's name) *or*

Hello (Project Name) Committee,

Beginning: State what you want.

- "I'm contacting you because…"
- "I understand you are searching for…"
- "In response to your call for…"
- "I was glad to hear of the opportunity in…"
- "Thank you for the opportunity to …"
- "I'm writing to ask if you are currently accepting…"
- "Your insert name of project is very exciting."
- "Thank you for your interest in my work, which I am happy to submit."
- "I learned about your gallery/project from reference name or source, and I'd like to invite you to view my work."

Middle: What can you offer?

This is the section of the letter most interesting to the reader. Re-use the best sentences from your artist statement, bio, or sentence-recycling bins.

- "In learning about your gallery/organization, I believe my work would be a good fit because…"
- "I believe I am a good candidate because…"
- "At this point in my career, I've completed…and I'm looking forward to…"
- "My experience has prepared me by…"
- "I am suited for this role because of my …"
- "The project you've outlined interests me greatly because…"
- "I can offer my skills in…"
- "I am prepared to…"
- "My intention, in alignment with your organization, is…"

End: Provide a list of everything you've attached or enclosed for the recipient. Conclude by emphasizing your interest and say thank you.

- "I've attached/enclosed nine images, my resumé, bio, and artist statement, along with the required submission forms."
- "I am excited about the possibility of…"
- "I'm very interested in pursuing this opportunity…"
- "I look forward to hearing from you… meeting with you…"

- "Thank you for your time and consideration."
- "I appreciate this opportunity."
- "Thank you in advance for your reply."

Some of these phrases may seem old-school, but good manners work in your favor.

The artist resumé

Your resumé is all about the details; it outlines your art-career specifics. You'll be using and adding to your resumé for a long time, so create a professional-looking document with formatting that works for you. A resumé that looks graphically current adds to a polished presentation. If you haven't reformatted your resumé in a while, you may want to give it a makeover.

Include only the categories that apply to you.

- Name, e-mail, phone, website (put this info on every page)
- Exhibits/installations/performances (include dates, exhibit space name and city, name of show, solo/group/juried)
- Education, training, residencies
- Reviews, publicity
- Collections, commissions
- Awards and grants
- Teaching or lecturing experience
- Art-related experience (boards, juries, committees, advocacy, writing)

Check a few different resources for guidelines to artist resumé writing, such as art-business books and art-school career resources. Suggestions differ and you'll need to make some choices for yourself. You can download free resumé formats using an online search for "artist resumé templates." Or you could pay a resumé-writing service to create the initial document, and then update it yourself from that point on.

You may come across the academic term "artist CV" (curriculum vitae), which is a comprehensive resumé containing every detail of your career. Experienced artists often edit down their resumé, selecting highlights to appeal to the chosen recipient.

Some of you, such as emerging artists or those who work outside of the gallery system, won't have a resumé. Move forward without one for now; focus on writing a strong artist statement and bio.

How to Write a Press Release

WRITING ABOUT YOURSELF DIRECTLY INFLUENCES WHAT is written about you, and nowhere is this more evident than when you write your own press release. A press release is the primary tool for attracting media attention, publicizing your exhibit, and attracting a larger audience. Also called a news release, this document is what media professionals expect to receive in their inbox to call their attention to newsworthy events.

Your gallery or show organizer will send out their own news release, and often they'll ask artists to contribute some writing for this purpose. The tone of a news release is different from other forms of art-writing. I'll explain how and provide guidelines for effective media communication.

The prescribed format for a news release hasn't changed in decades, although today most are e-mailed. With many

templates and examples on the Web, the common advice on how to write a press release urges you to "make it attention-getting." But what does that mean? Animation graphics? Delivery by owl?

It means, as you've heard before, considering your audience. Media people are highly caffeinated, deadline-driven individuals who want a press release written the way they expect it to be written: with correct formatting, and with all the facts stated quickly. Make them like it! A media pro will approach your news release in the same way you scan the daily news: you glance at the headline and the first few sentences and decide if you'll read more.

> The audience for your press release is different than the audience for your artist statement.

News writers are like birds looking to find pieces for the nest they're building, called a story. They would like nothing more than to pluck your words and stick them directly in their story. The news release is primary nest-building material, so write sentences that are attractive, useful, and easy-to-carry. For example, you will include quotes because news writers love to use quotes to weave together a story.

Before you attempt to write your own press release or material for your gallery's release, read a few news stories in the Arts Section. Study the headline, the lead sentence,

and the closing. What information did the writer need to pull together the story? That's exactly the type of information you need to provide.

Here's the format for a press release, including guidelines for artists:

- FOR IMMEDATE RELEASE (put this all in caps and align left.)
- Media contact: Name
- Phone number
- E-mail
- Website (This will be your contact information or your gallery's information, not both. Stack these four lines of contact information and align right.)
- Headline (In Bold, one font-size larger than the rest of text. Capitalize the first letter in each word and align center.)
- Date of release, year, city, state (Place in parentheses.)
- Lead sentence (The main event: who, what, where, and when. State the title of the show in all caps, even if you've already stated the title in the headline.)
- Describe the show physically. Create an image in the reader's mind.
- Write about the theme, inspiration, context, or meaning of the show. Focus on what might entice readers to come see the show for themselves.
- Quote from the artist about the show.
- Quote from someone else, like the gallery director, sponsor, show organizer, or a known artist who will endorse your work. (Skip this step if you don't have a quote.)

- Second quote from the artist (This is optional, but a good way to summarize. If you choose not to use a second quote, write a concluding sentence.)

- About the artist (Introduce this section with those words. Insert your bio, or an edited version of your bio that emphasizes your most recent accomplishments or creative focus. The reader is scanning for standout descriptions, so mention honors, grants, publications, and affiliations. Build yourself up.)

- About the (name of) gallery/venue (Include the address, hours, website, phone number, directions, and all opening-event details. If this is your gallery's news release, they will provide this and you can stop here.)

- For more information (Repeat media contact name and details. For high-resolution images: Where can the media access images of your art for publication?)

- ### (These marks indicate the end of the press release. Align center.)

Writing your headline:

The headline is an important part of your press release. Here are few formulas for writing one:

Adjectives describing artist + verb: Title of show at gallery name

Reclusive Punk-Era Painter Emerges for Group Show: YES, OFFICER at Twin Palms Gallery

The headline created the question, "What's the name of this artist?" Good question! The lead sentence should then begin with the artist's name.

Adjectives describing artist + artist's name + verb + describe art: Title of show at location

Kendall Faculty Member J.J. Jones Reveals
Intriguing Temporary Art Installation:
NOT NOW! in the Beck Arboretum

Title of show: Type of work by name of artist at name of gallery-Dates

PRIVACY: Recent paintings by Lee Míng
at The Dwyer Gallery-
October 3-November 3, 2013

Tips for effective media writing:

A news release is no place to be humble. Refer to yourself as, "noted, popular, published, award-winning, recognized, established, accomplished, intriguing, prominent, celebrated, recognized for, known for..." These are media-type words and they help to construct a good story. You can at least say, "Noted for her (descriptive) style." Hey, you noted it, right?

You'll be writing in the third person. Don't use "I" or "me" in your news release unless you are quoted!

Write short paragraphs. Create easy-to-skim chunks of text. A press release should not be longer than two pages.

Let's put this all together in the following fictional example:

FOR IMMEDIATE RELEASE

Media Contact: Lee Míng
503-897-0000
mingpainter@arts.net
http://mingpainter.com

Realist Painter Lee Míng Examines Erosion of Private Life: PRIVACY Series at The Dwyer Gallery

(September 21, 2013, Seattle, WA) Chinese-American realist painter Lee Míng announces his major new series, entitled PRIVACY, opening in a group show at The Dwyer Gallery on October 3 and continuing through November 5. The opening reception for SEATTLE CONTEMPORARY ARTISTS, including PRIVACY by Lee Míng, takes place Friday, October 3, from 6:00-9:00 p.m.

The six paintings comprising the PRIVACY series, awash in vibrant color, are sure to dazzle visitors to The Dwyer. Míng's unique approach to blending oil pigments and up to 10 layers of resin creates gem-like surfaces. Peering through the surface to what is depicted below, the viewer realizes that all is not as glowing as it first appears. Míng is noted for his deft rendering of complex realism.

Míng also explores a complex subject; his work calls attention to our culture's surrender of pri-

vacy. Much of Míng's artwork is influenced by his experience as a Chinese immigrant to the United States. Through this new body of work, he connects privacy to social class: the wealthy purchase privacy while the middle class give up their privacy without much thought.

Says Míng of his PRIVACY series, "I grew up spending a lot of time at the Seattle Public Library, and I still go there. When I found out the FBI can request information about library patrons' reading lists, it reminded me of stories my parents told me about living in China. I started thinking about privacy and what it means anymore. My paintings have always dealt with the surface and what's beneath the surface, so the concept of privacy—what's revealed and what's hidden—seemed like the perfect subject to explore in paint."

The Dwyer Gallery director, Charlotte Burnside, says, "We are thrilled to include Míng in this year's SEATTLE CONTEMPORARY ARTISTS. His paintings for the PRIVACY series were all completed in the past year and I believe audiences will find his work both striking and timely."

"The subject of privacy in our current world grabbed my attention and wouldn't let go," states Míng. "My fascination and intense focus is revealed through my paintings."

About the Artist: Lee Zhì Míng was born in Beijing, China, in 1976, and he immigrated with his family to Seattle, Washington, at the age of ten. Míng received a scholarship to Seattle University's College of Arts and Sciences. His work is exhibited and collected nationally. Ming resides in Seattle and contributes to Platform Creatives.

About the Dwyer Gallery: The Dwyer Gallery offers contemporary painting, sculpture, and prints. 300 Occidental Avenue South, Seattle. (206) 455-0000. www.thedwyer.com.

SEATTLE CONTEMPORARY ARTISTS, including PRIVACY by Lee Míng, Oct 3 - Nov 5. Opening reception Friday Oct 3, 6:00-9:00 p.m.

For more information and high-resolution images contact:

Lee Míng, 503-897-0000
mingpainter@arts.net
http://mingpainter.com

###

It's easy to see how a writer covering this show would be very likely to mention this artist. The artist handed them a great story!

Writing a press release is a proven publicity method and it costs you nothing but time. E-mail or mail your news release to all the media outlets you can think of, as well as arts organizations and bloggers. In addition, send out the release to your personal contacts and post it to social-media. Use the news release as your professional announcement, even if you also publicize your show with a printed postcard or digital announcement with graphics and images. (It's a good idea to let your gallery know you plan to send out your own news release.)

Look Again

Keep an Art-Write file

To maintain an easy-to-use reference, keep a file of writing that contains:

- Your current artist statement
- Previous artist statements
- Sentence-recycling bins
- Bio
- Resumé
- All of your writing scraps, notes, and inspirations
- Recorded conversations
- Copies of application forms and proposal documents
- Copies of cover letters
- Copies of press releases

This composes your complete Art-Write file. It may

take a while to write all the pieces, but as you know, deadlines produce results. Build it as you go.

Start the self-promotional engine

Writing is the key that starts the self-promotion engine.

Now that you have *Art-Write* as your writing guide, it will be much easier to take in all kinds of marketing advice and adapt it to your own career. Look to what the experts in self-promotion have to say. Continue to find more business resources for artists. Read all you can, at your library, bookstore, or online. Some resources may be outdated or generalized, but usually you can glean some useful bit of information.

Resources

Here are a few resources I've read and enjoyed. There are many more—this is just the beginning!

Want free online advice from the perspective of an art consultant and advisor?

Alan Bamberger, Articles for Artists

http://www.artbusiness.com/artists.html

Small book, grand advice: *Steal Like an Artist: 10 Things Nobody Told You About Being Creative* by Austin Kleon.

Want to build your online presence and gain the confidence to self-promote?

I'd Rather be in the Studio: The Artist's No-Excuse Guide to Self-Promotion by Alyson B. Stanfield.

http://www.artbizcoach.com

Interested in a grant? *The Artist's Guide to Grant Writing* by Gigi Rosenberg.

Looking for inspiration from an eloquent art writer? *Let's See* by Peter Schjeldahl.

Need a push to take innovative marketing approaches? *Making It in the Art World: New Approaches to Galleries, Shows, and Raising Money* by Brainard Carey.

Checking your grammar? Visit Grammar Girl at http://grammar.quickanddirtytips.com/

Searching for words? Check definitions and synonyms http://www.wordnik.com/

Seeking more connections and opportunities? Join the e-mail lists of local arts organizations in your city, county, state, and region.

Enthusiasm is at the heart of marketing, so go out and find a jump-start when you need one. Take a workshop in grant-writing or career-building skills. Search for classes in professional practices. Connect with other artists, in person as well as online. Submit numerous applications; you'll improve your writing skills as well as your chances for success. There are opportunities waiting, more to learn, more to express, more to write.

Maybe you didn't expect to be doing self-promotion when you contemplated a life in the arts, but such are the times we live in.

Now take the writing you accomplish with the help of *Art-Write* and use it!

And remember...

Writing to promote yourself requires a certain polish, but the shine is not as important as the substance. What is real and true about your work? That's your touchstone.

Words are powerful. Words can lead the audience to your art, piquing their interest, firing their synapses, and opening their wallets.

After all the volumes written about art, I believe art appreciation comes down to the act of looking—truly looking—and then looking again.

The task in front of you revolves around these two questions:

1) What can I write that might help someone *see*?

2) What more can I write that might help someone *look* again?

I wrote this book because I think the world needs more art. A written statement has the potential to enhance a visual statement and to help artists sustain more art-making.

You can find the right words. You can write about your work. Everything you need is right in front of you.

"An artist is a person who has invented an artist."
—Harold Rosenberg

Acknowledgements

I AM GRATEFUL TO PATRICIA MARSHALL, MY EDITOR, FOR her enthusiasm and marshalling abilities. Thank you Betsy Wolfston, for the open door and the laughs. Authors Laurie Notaro and Marissa Meyer, you each gave me a well-timed spark. Paul Mavrides, I appreciate the elegant book cover and your friendship. Thank you for your assistance Katrina Woltze of Laura Russo Gallery, Beverly Soasey of Jacobs Gallery, John Rose, Kathy Staats-Hornbeak, Chanin Santiago, Judith Osborn, Cecelia Hagen, and Peg Goldstein. I appreciate the discerning opinions and kind hearts of Denise Slattery and Catherine Flynn-Purvis. You helped me more than you know Paula Prober, Sue DeWhitt, Sarah Whistler, and RuPaul Charles. And thanks to Katherine Krohn and Gerard Alcantara for the legendary museum tale.

VICKI KROHN AMOROSE IS AN ARTIST, WRITER, AND voiceover talent. Her background as an educational media writer, advertising copywriter, art instructor, museum docent, and gallery manager has prepared her to synthesize the *Art-Write* viewpoint. She studied art history at University of Michigan and fine art at Academy of Art University, San Francisco. Her fondness for art and the people who make it led her to write this book. She lives in Eugene, Oregon, with her husband, daughter, and son.

Contact her at www.artwritebook.com

CPSIA information can be obtained
at www.ICGtesting.com
Printed in the USA
BVHW081323100220
571912BV00001B/182

9 781937 303129